MW00883751

Forest Wildlife
Coloring Book

An Adult Coloring Book Featuring Beautiful Forest Animals, Birds, Plants and Wildlife for Stress Relief and Relaxation

Copyright 2019 © Coloring Book Cafe

All Rights Reserved.

Copyright @ 2019 Coloring Book Cafe
All Rights Reserved.

All rights reserved. No part of this publication may be reproduced or used in any form or by any means--graphic, electronic, or mechanical, including photocopying, recording, or information storage-and-retrieval--without permission of the publisher.

The designs in this book are intended for the personal, noncommercial use of the retail purchaser and are under federal copyright laws; they are not to be reproduced in any form for commercial use. Permission is granted to photocopy content for the personal use of the retail purchaser.

an Imprint of **The Fruitful Mind Publishing LTD.**
www.coloringbookcafe.com

Have questions? Let us know.
support@coloringbookcafe.com

 facebook.com/coloringbookcafe @coloringbookcafe

This Book
Belongs To:

Badger

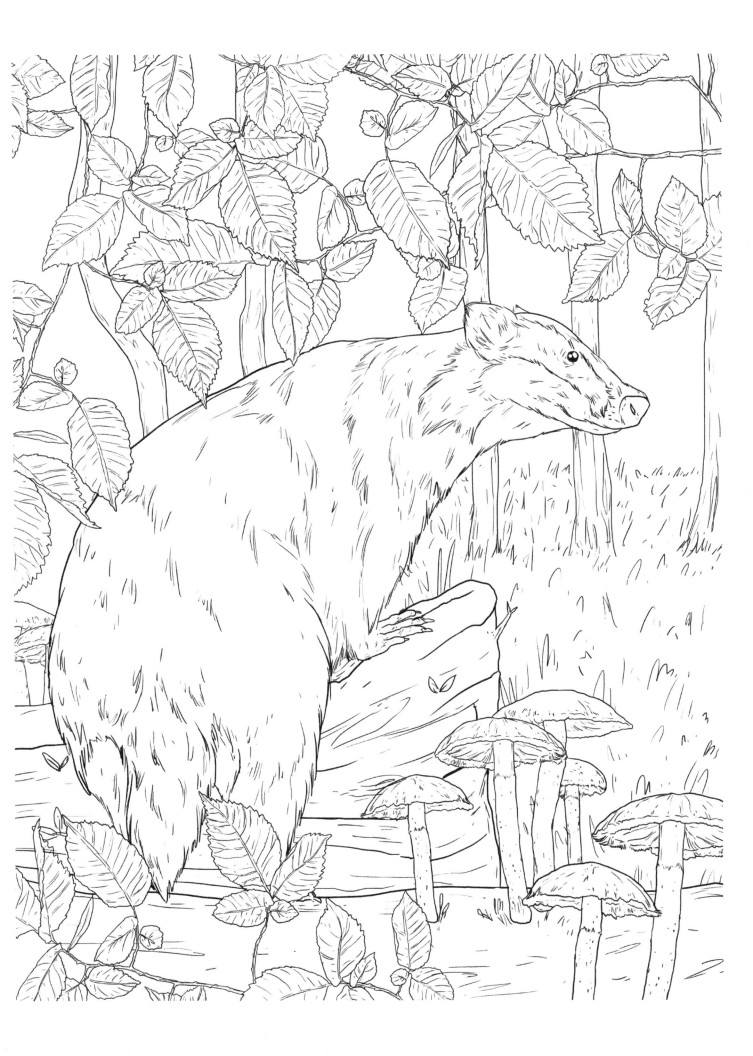

Bat

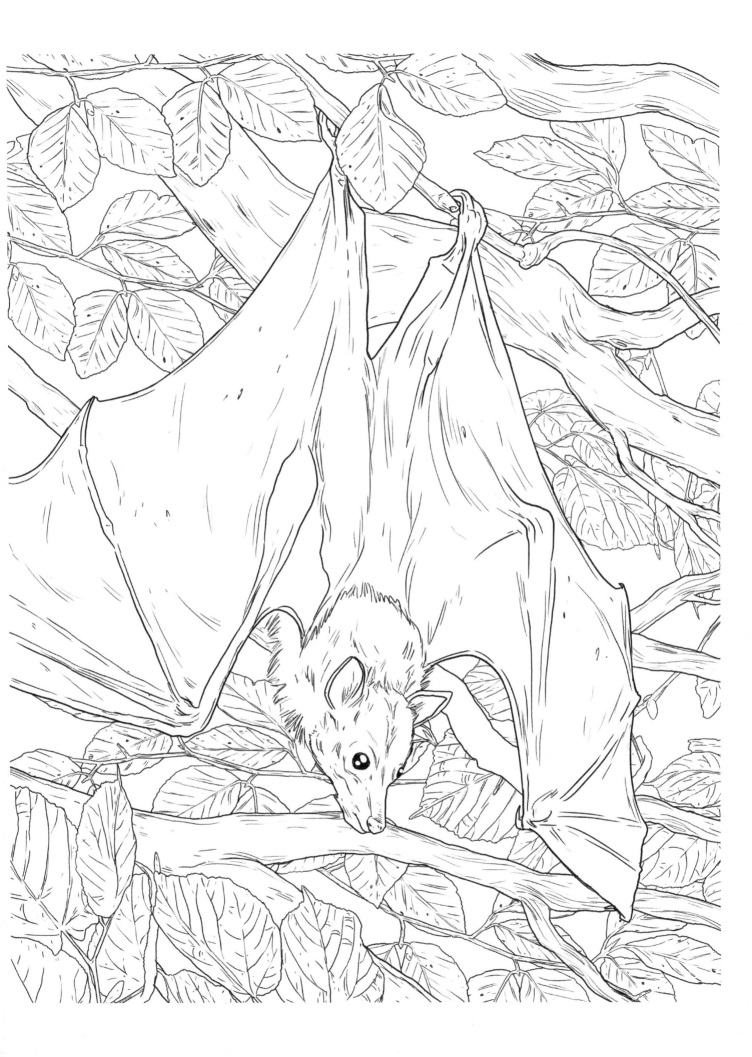

Bears

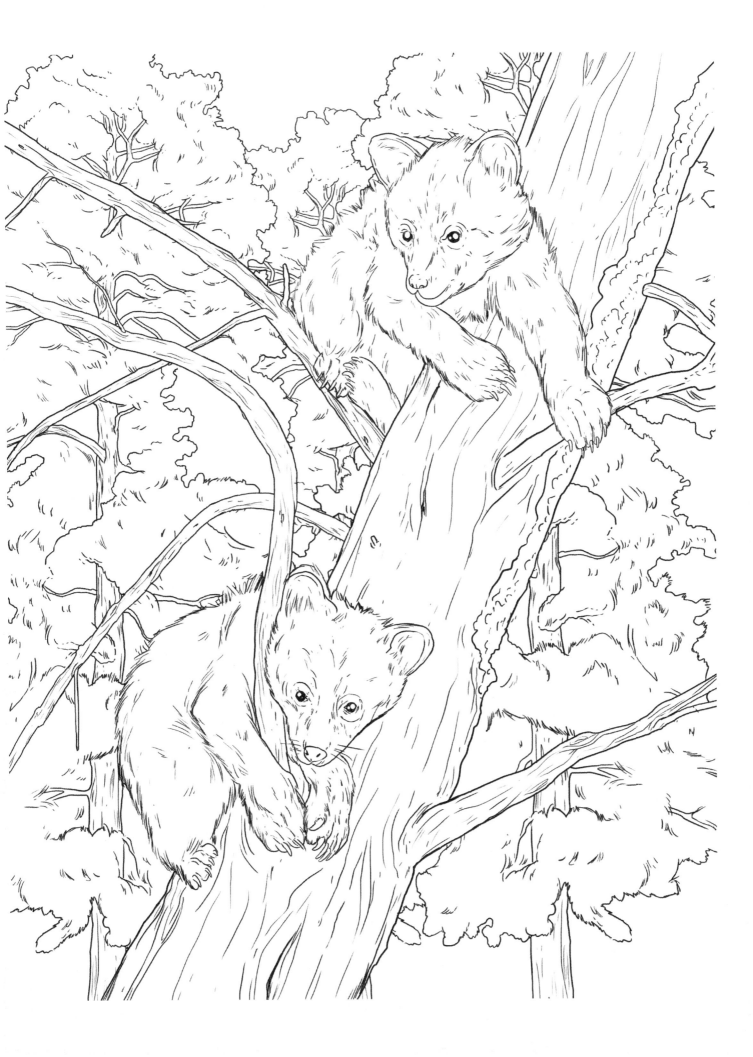

Beaver

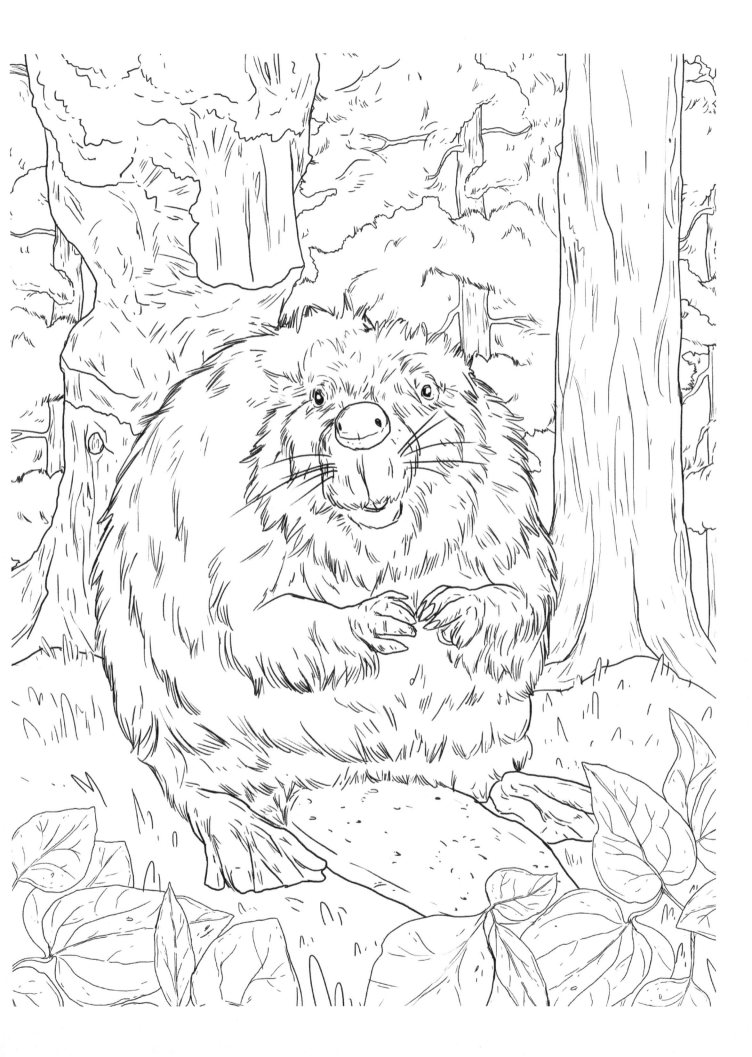

Boar

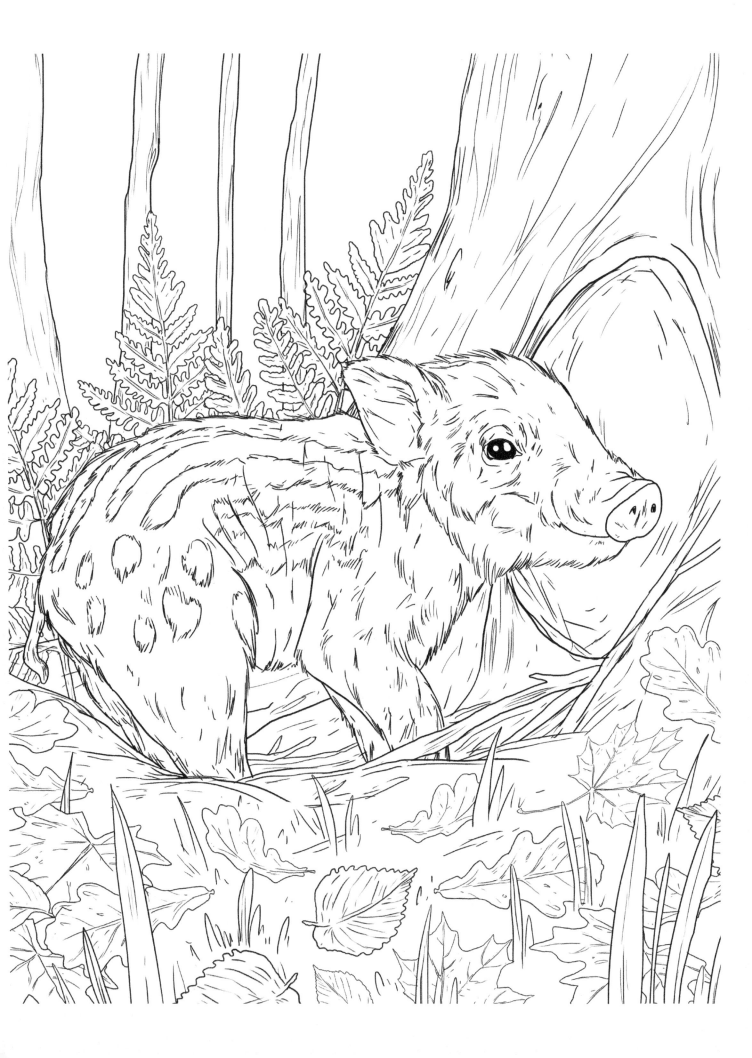

Bobcat

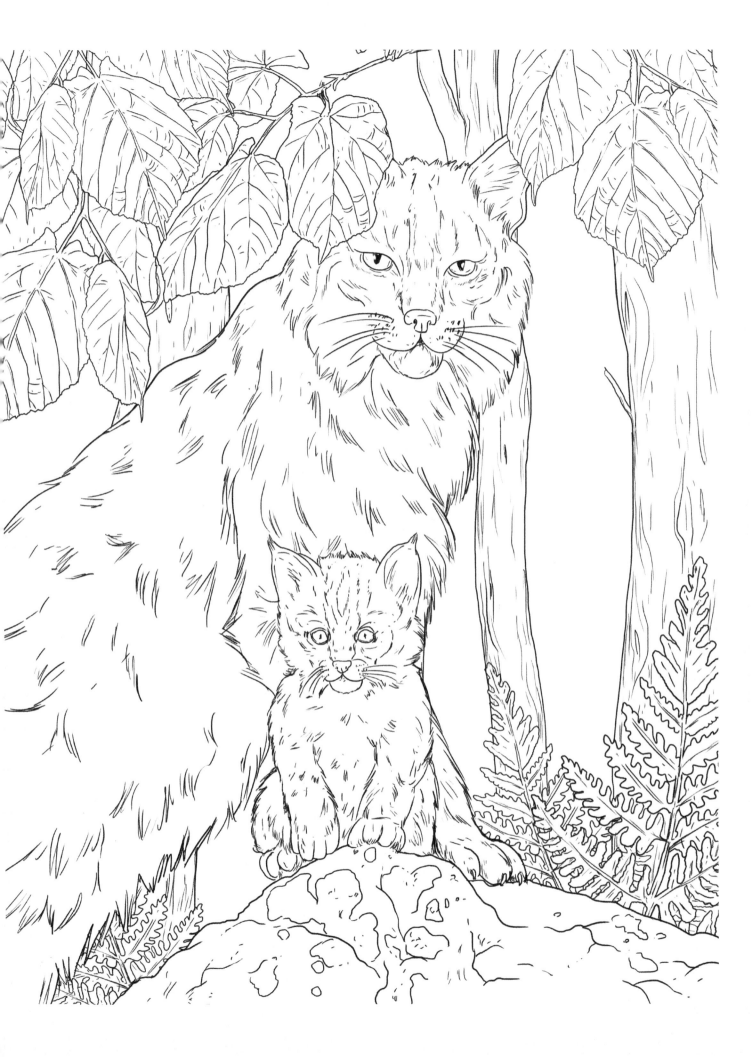

Deer

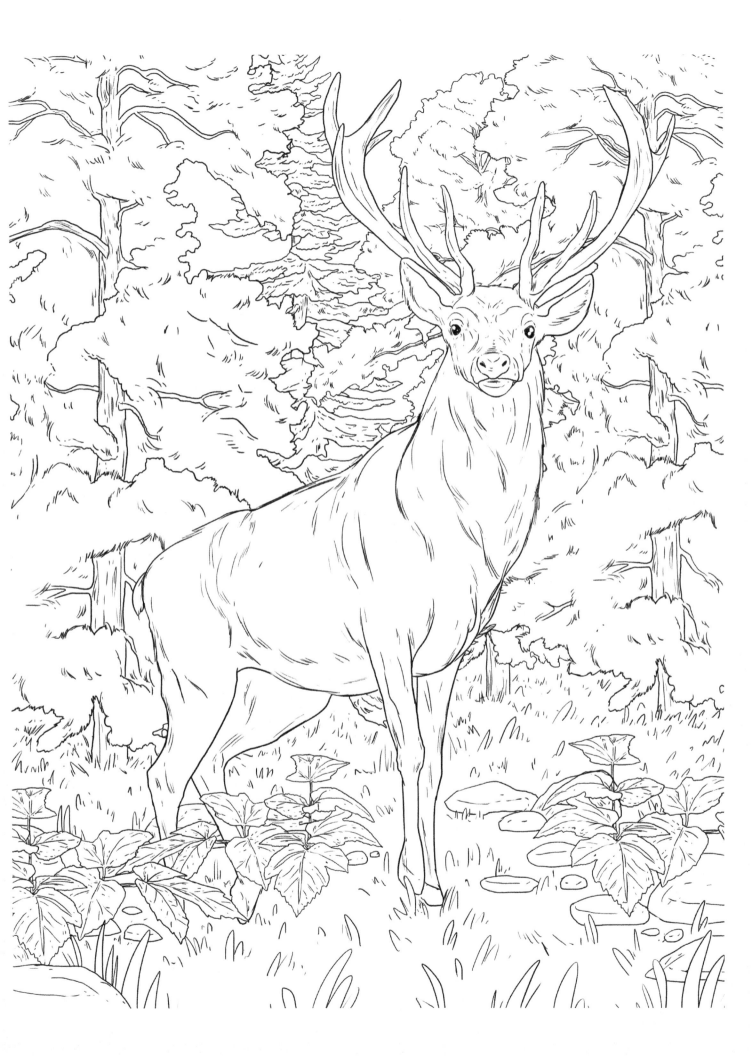

Eagle

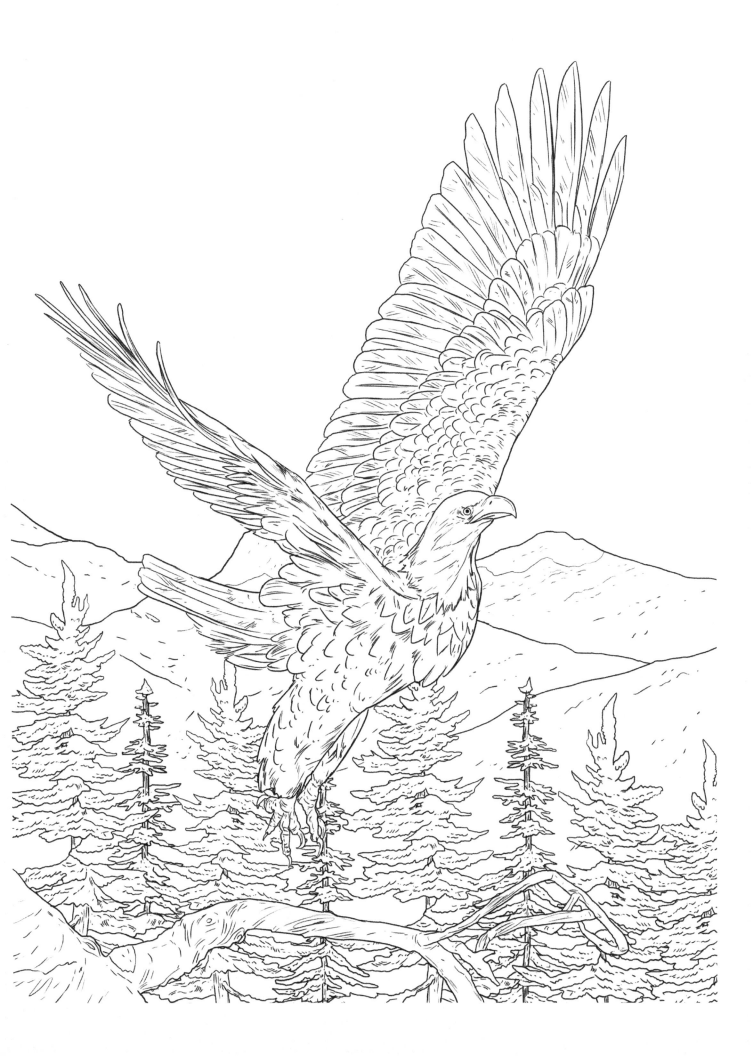

Forest Lion

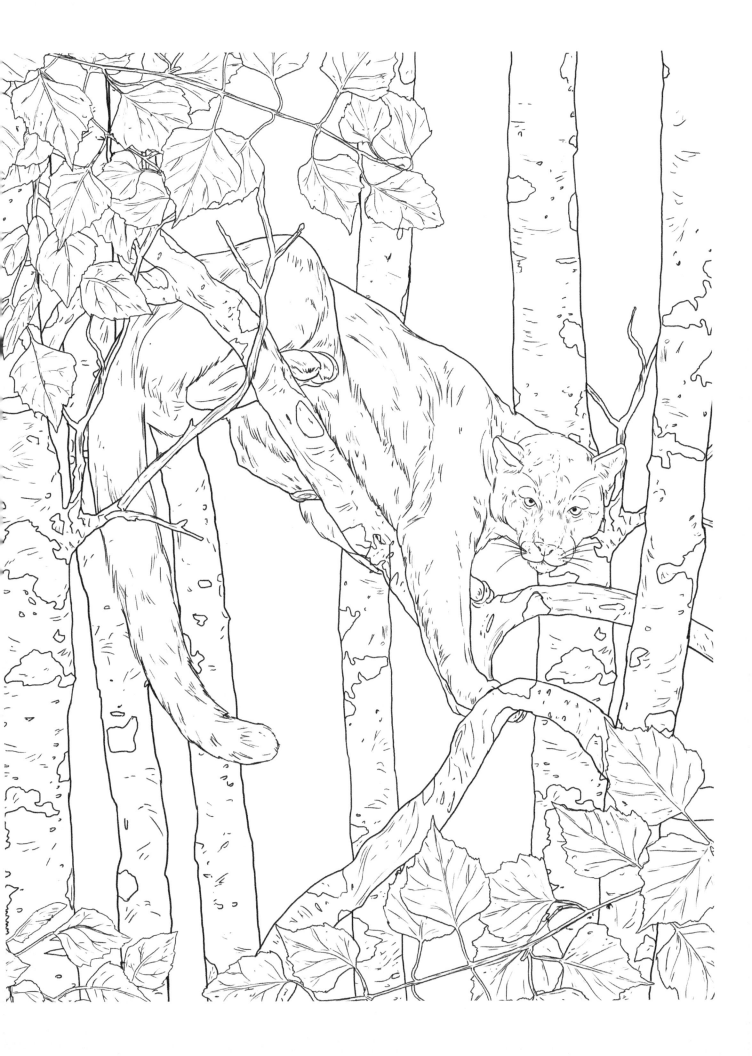

Fox

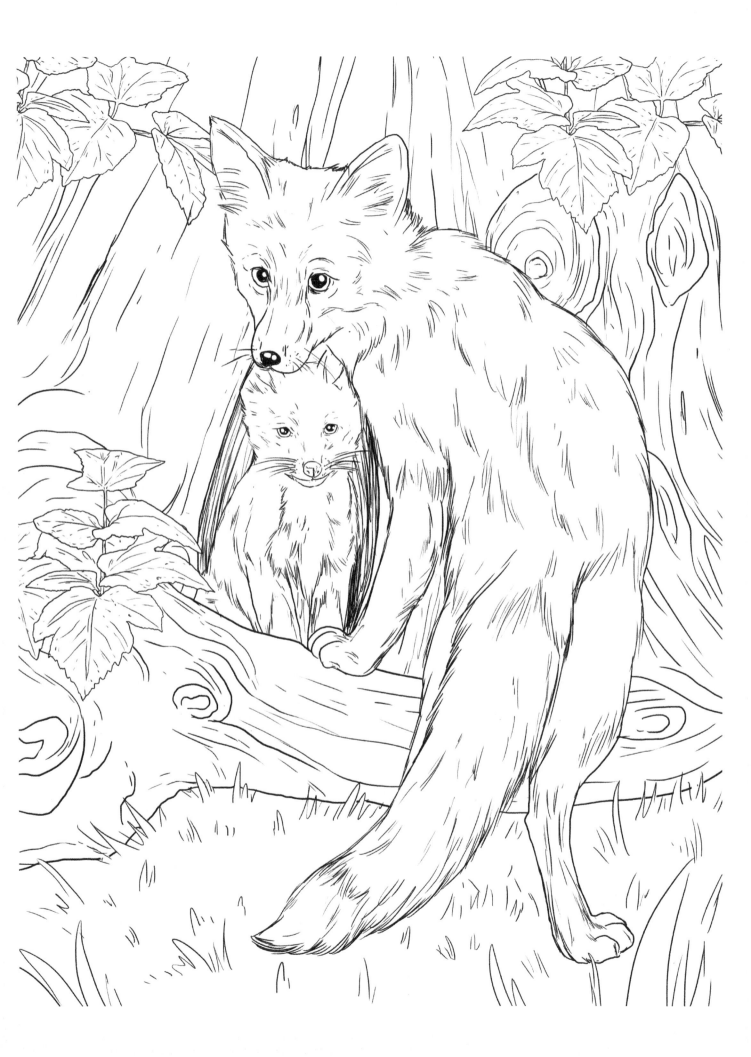

Gopher

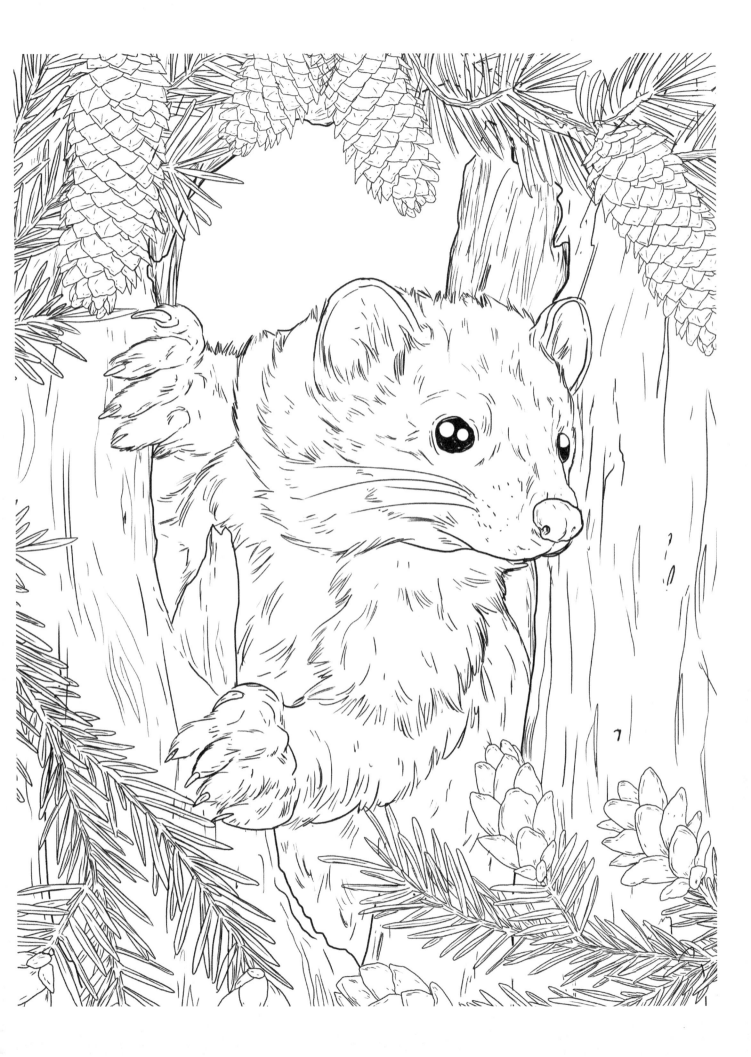

Hedgehog

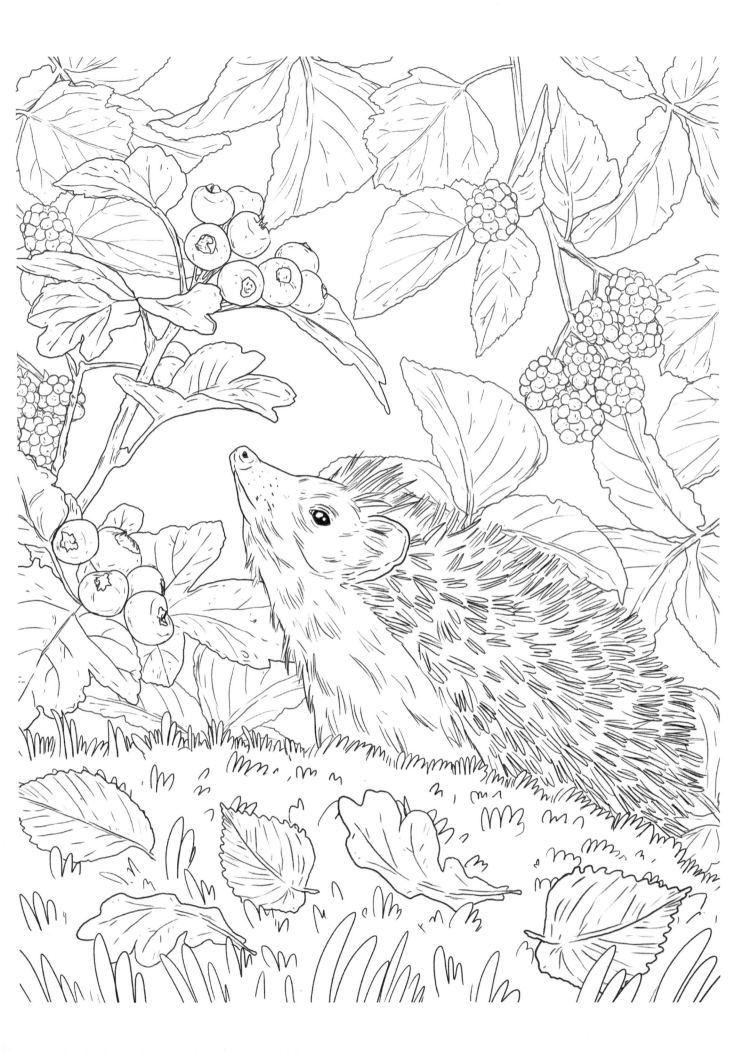

Ladybug

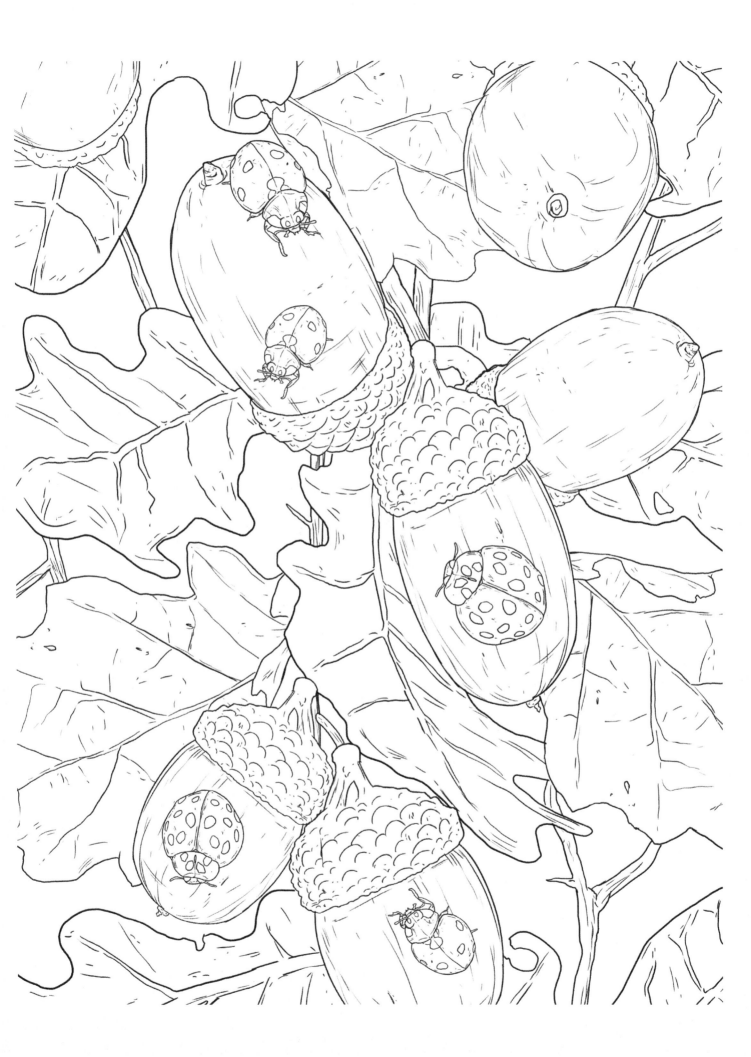

Mushroom Mouse

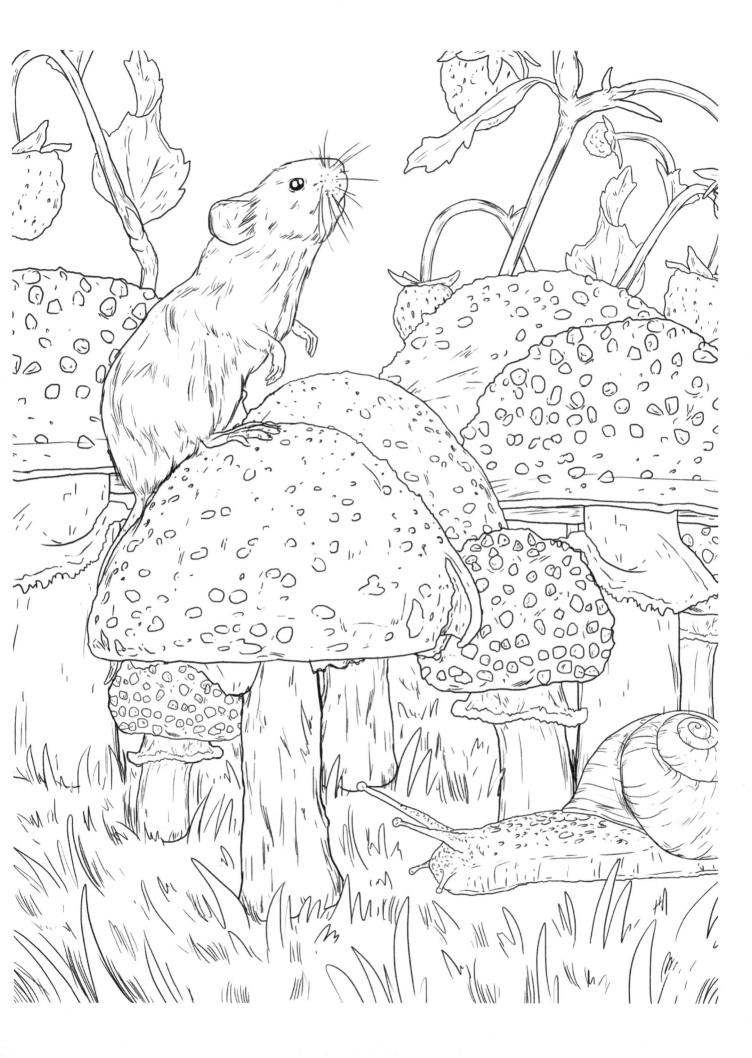

Moose

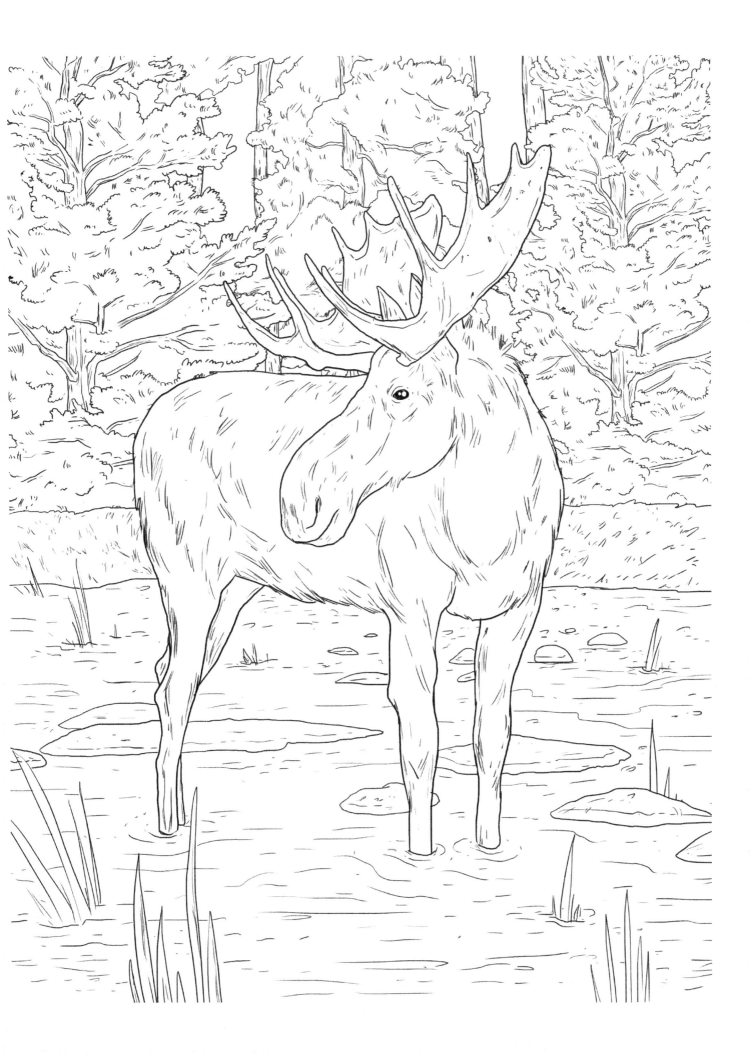

Nest

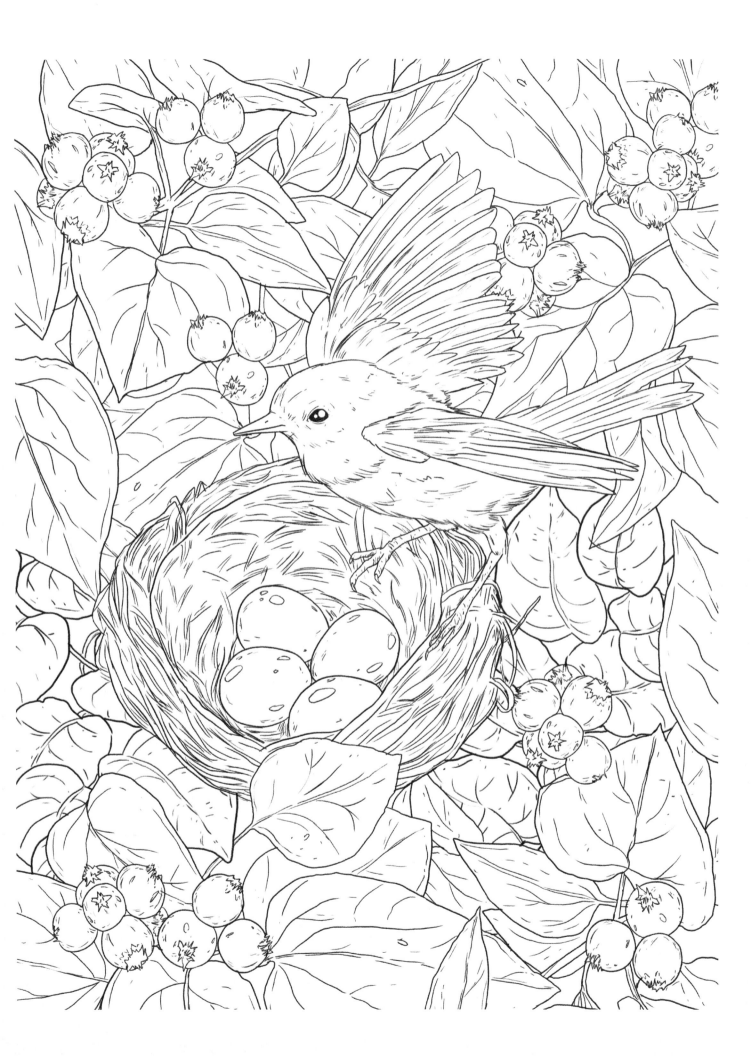

Opossum

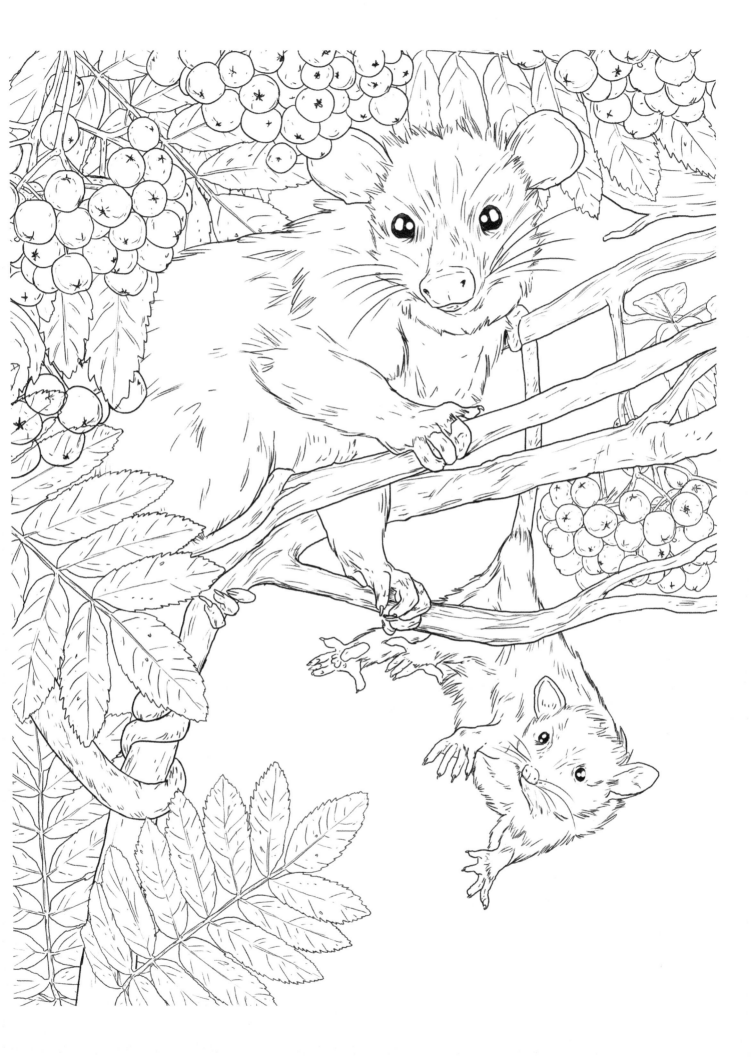

Otter

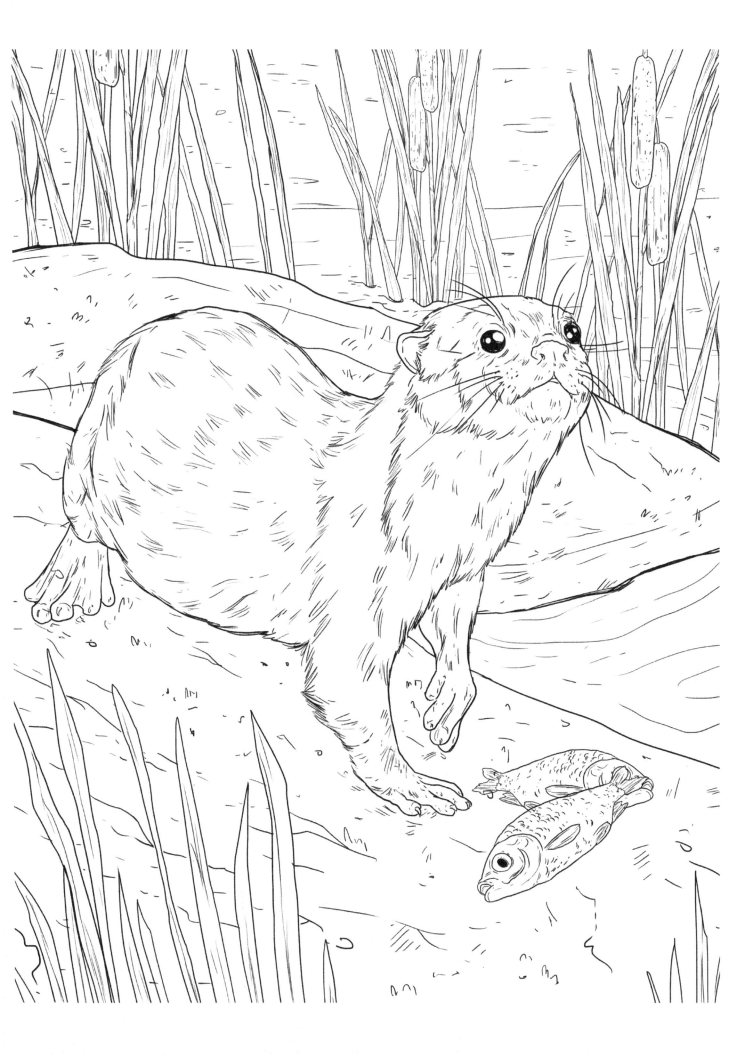

Owl

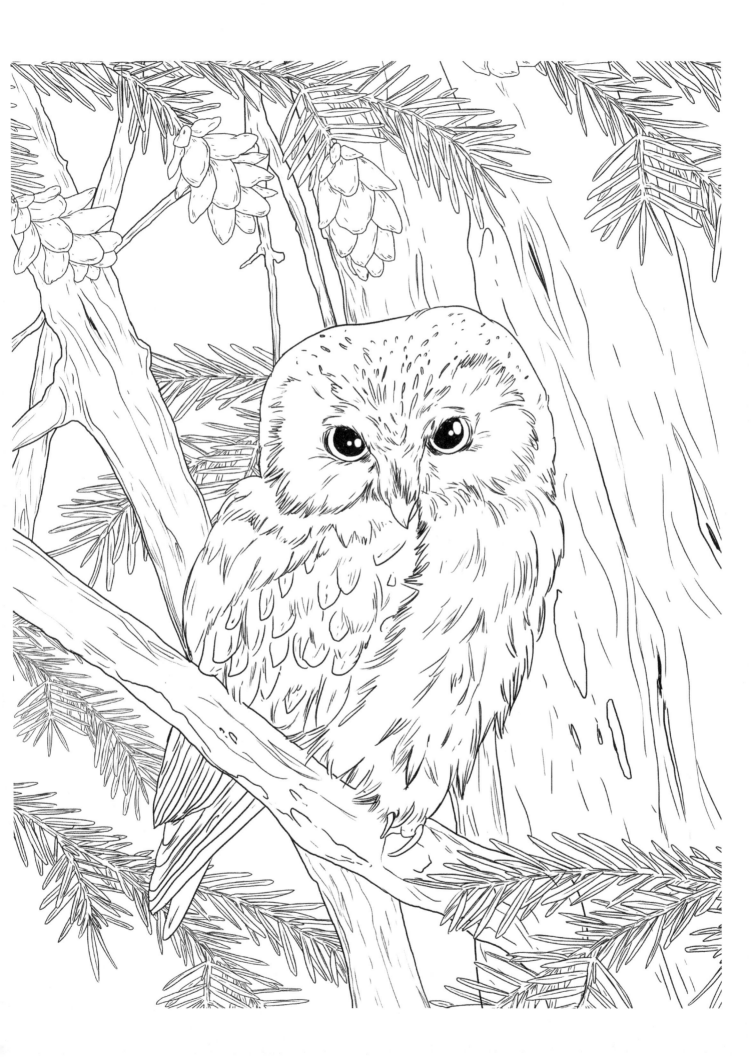

Pangolin

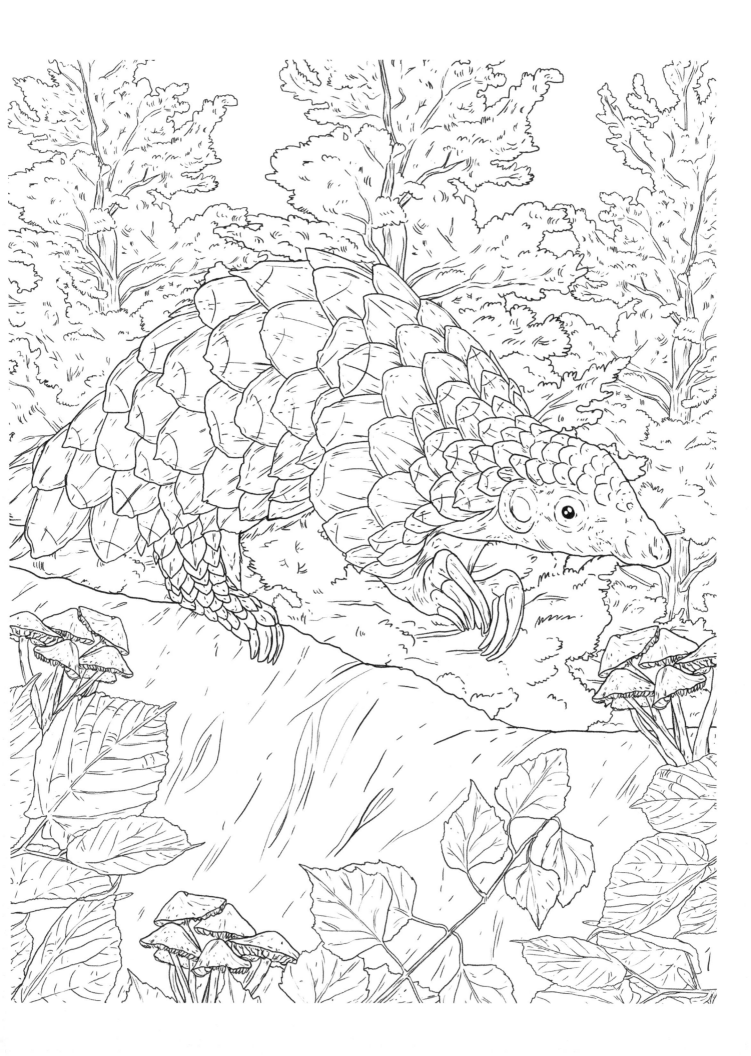

Rabbit

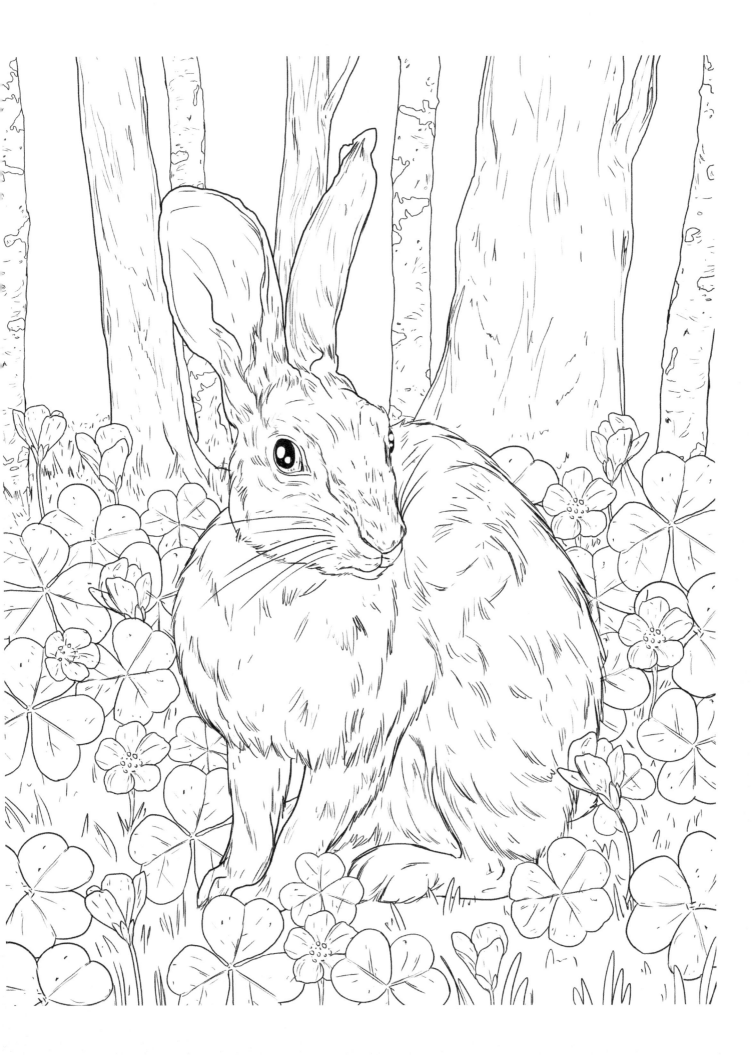

Racoon

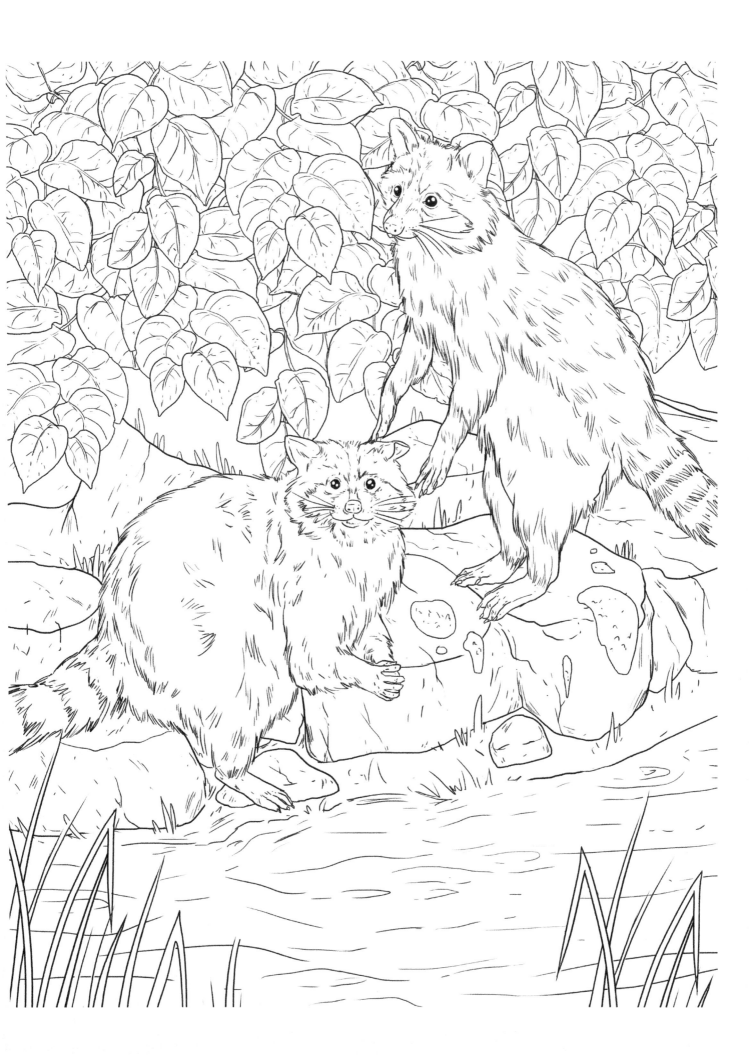

Squirrel

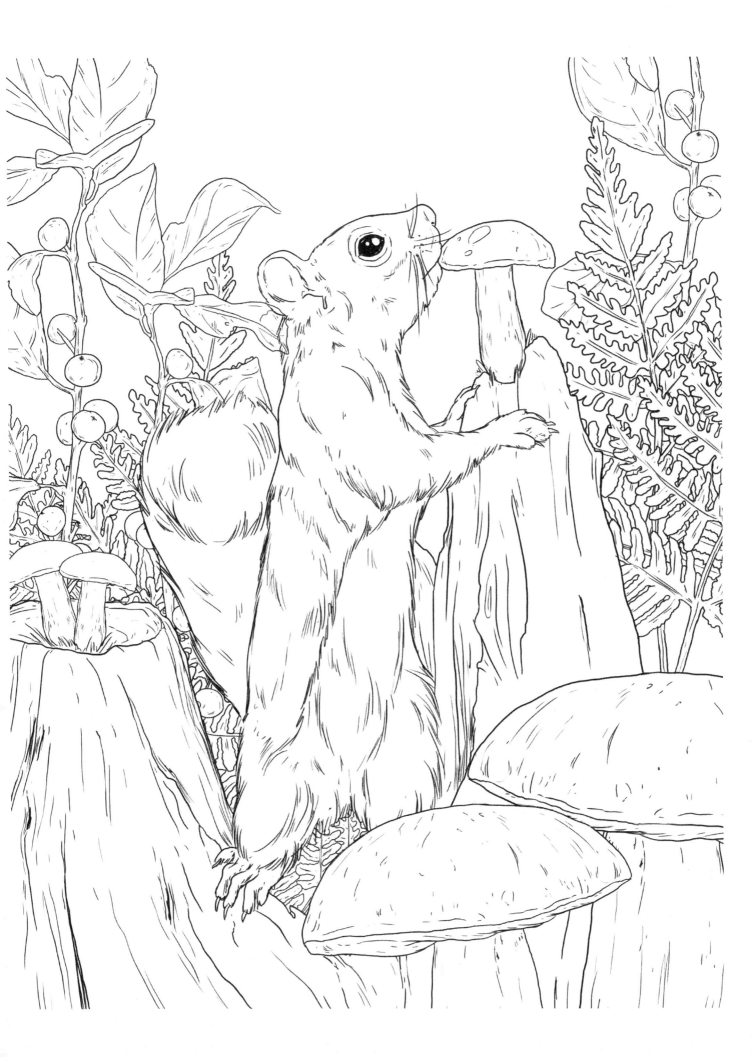

Wolf

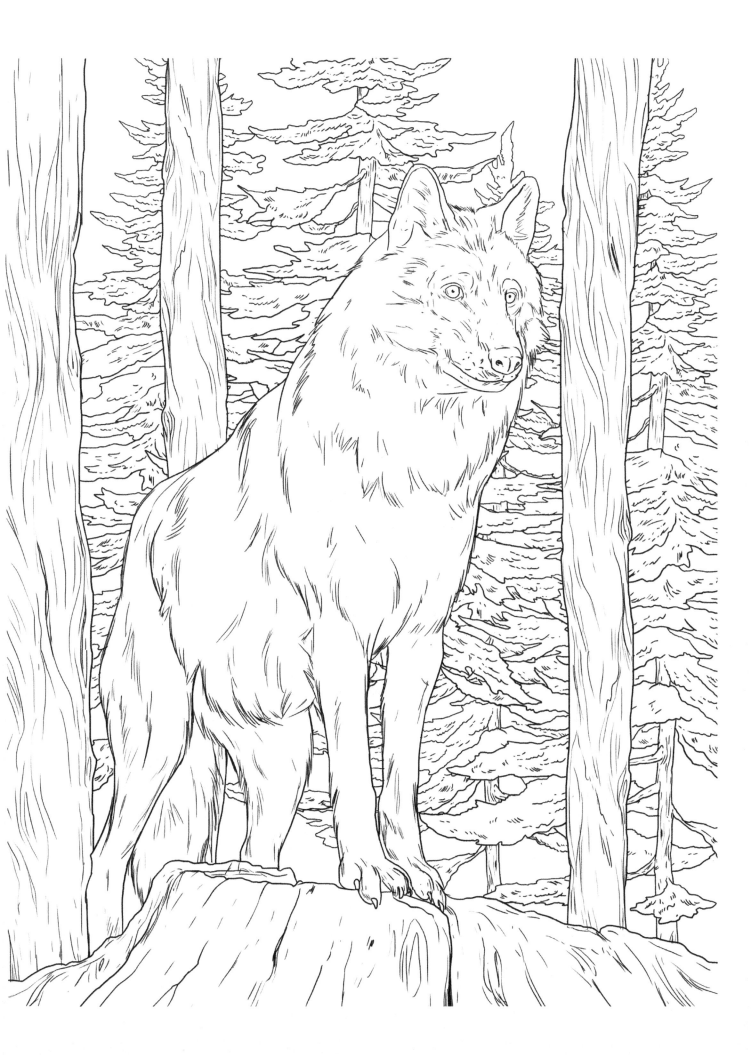

Woodpecker

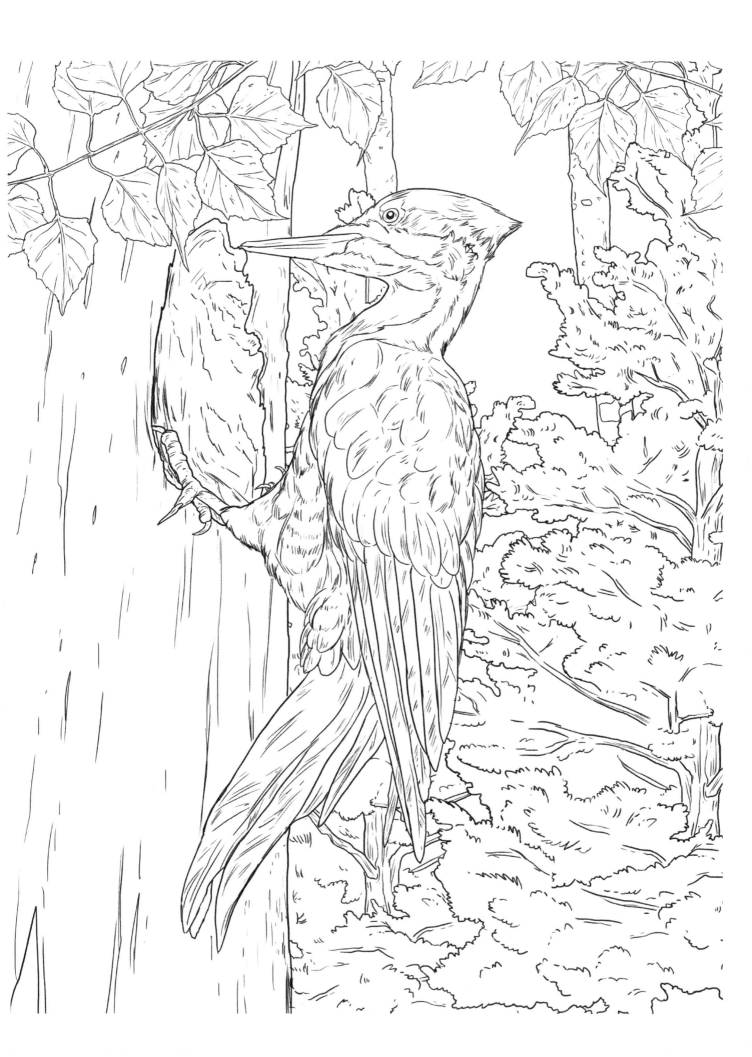

Made in the USA
Columbia, SC
12 January 2023

10176800R00030